The Noodle Kittens Art Series

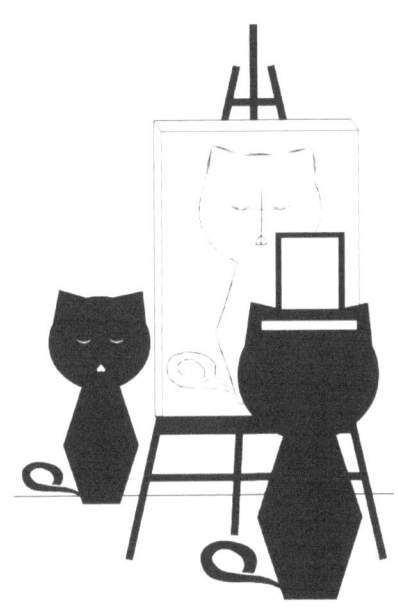

Ryoko San

The Noodle Kittens Art Series

by
Ryoko San

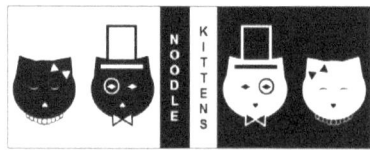

www.noodlekittens.com

Copyright © 2012 Gabrielle Wenonah Wriborg
Slinkster Ink Publishing
www.slinksterink.com
All rights reserved.

ISBN: 1478164018
ISBN-13: 978 – 1478164012

For all the cats in my life of past, present, and future: thank you for gracing me with your presence.

Table of Contents

The Noodle Family	2
Preface	3
Four Noodle Kittenses	4
American Gothic	6
Composition in Red, Blue, and Yellow	8
Pest Modernism	10
Blue	12
Symphony in Black	14
Cubist Kitten	16
Proun	18
Morning Kitten & Evening Kitten	20
After Dark	22
Flower That Blooms at Midnight	24
Arithmetic Composition	26
The Last Mad Tea Party	28
Noodle Notes	31

The Noodle Family

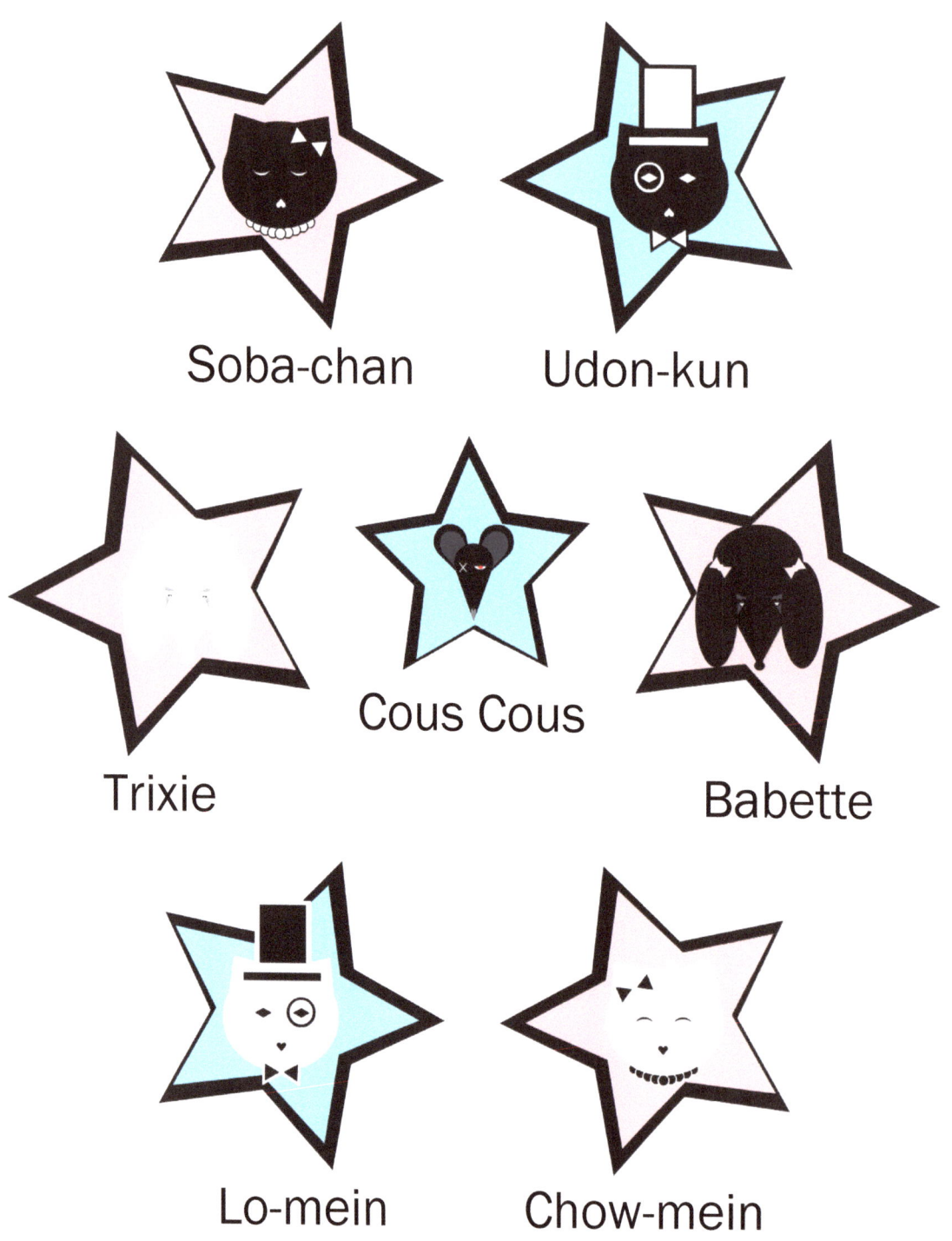

Preface

I first met Soba-chan and Udon-kun hanging out in my imagination. On August 12, 2010, the two black kittens decided to saunter from the imaginary plane into the virtual world. In no time, the Noodle family grew and now resides in a digital kennel on the internet.

In December of 2010, I started a thirteen piece series intended as an homage to some of my favorite artists, art works, and art movements. I created one piece per week for thirteen weeks until the series was completed in March of 2011. It was an exciting project to undertake as it allowed me to spend time learning more about the history and theory of a variety of art movements. I loved trying to determine who or what to emulate, the extensive research process, and the subsequent sketching of ideas. I fondly remember spending hours searching for and devouring as much information as I could until I had gorged myself on a veritable feast of data and imagery. I enjoyed manipulating the Stripgenerator design tools in order to reproduce the visions that appeared in my imagination. I marveled at how ideas naturally evolve throughout the creative process, and how the finished product can be completely different than the original vision. It was a challenging yet meditative experience that helped me realize a sense of serenity that all artists strive to feel.

For your viewing pleasure, I present The Noodle Kittens Art Series. There is a section of Noodle Notes after the 13 pieces that states the artistic inspiration and if applicable, the title inspiration for each piece. It also contains a few interesting facts I learned through my research I thought worthy of sharing. Please enjoy!

~Ryoko

Four Noodle Kittenses

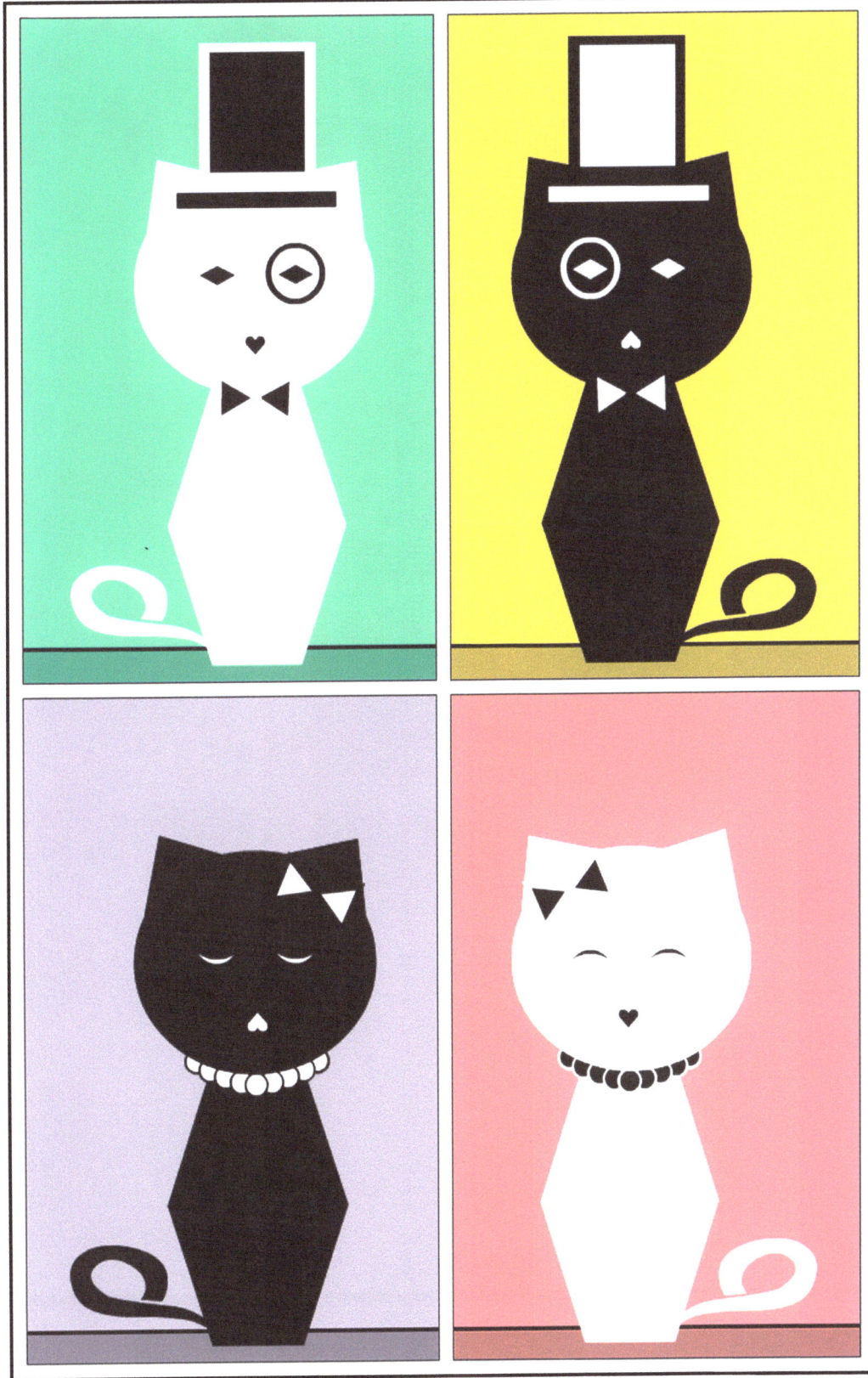

American Gothic

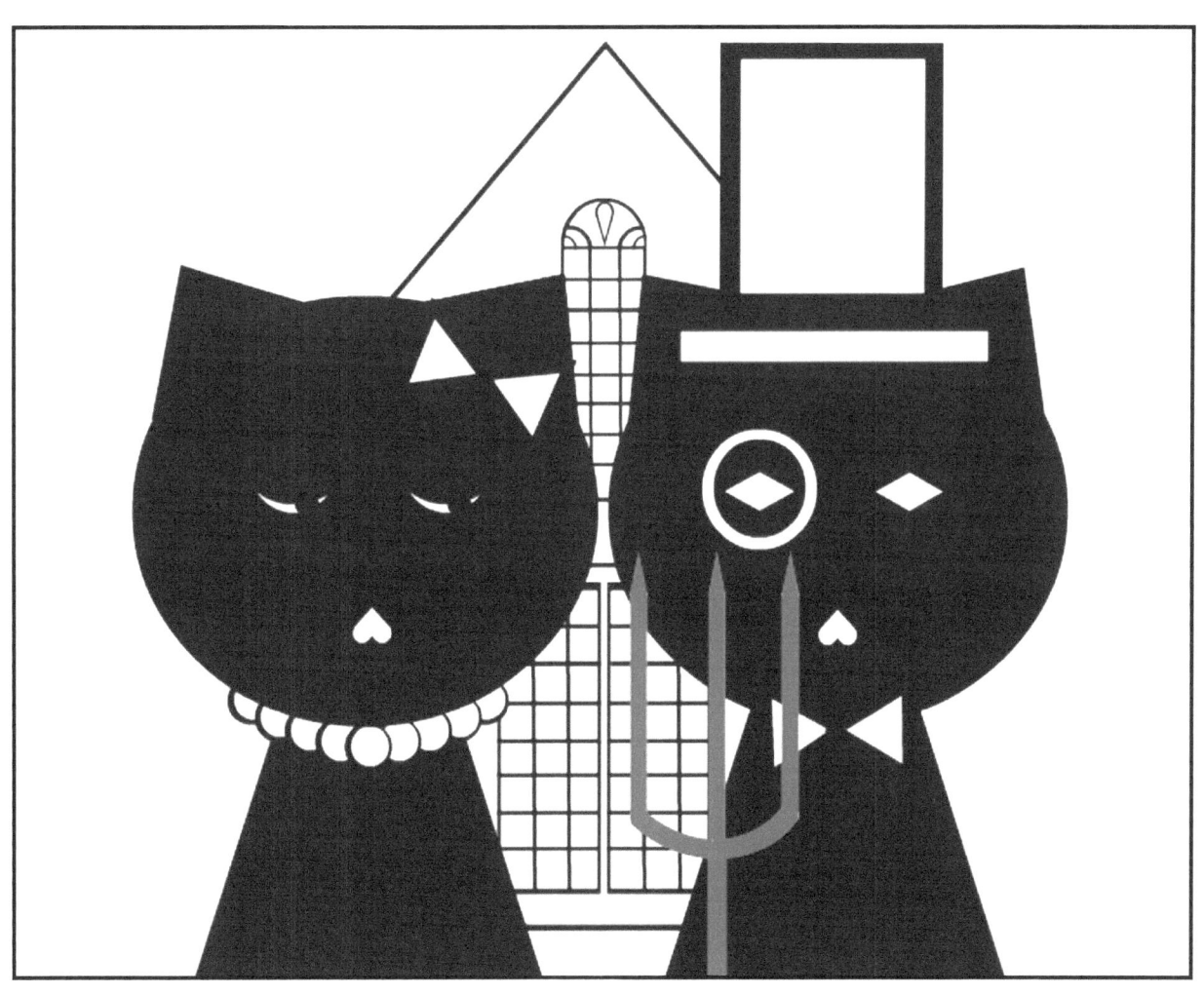

Composition in Red, Blue, and Yellow

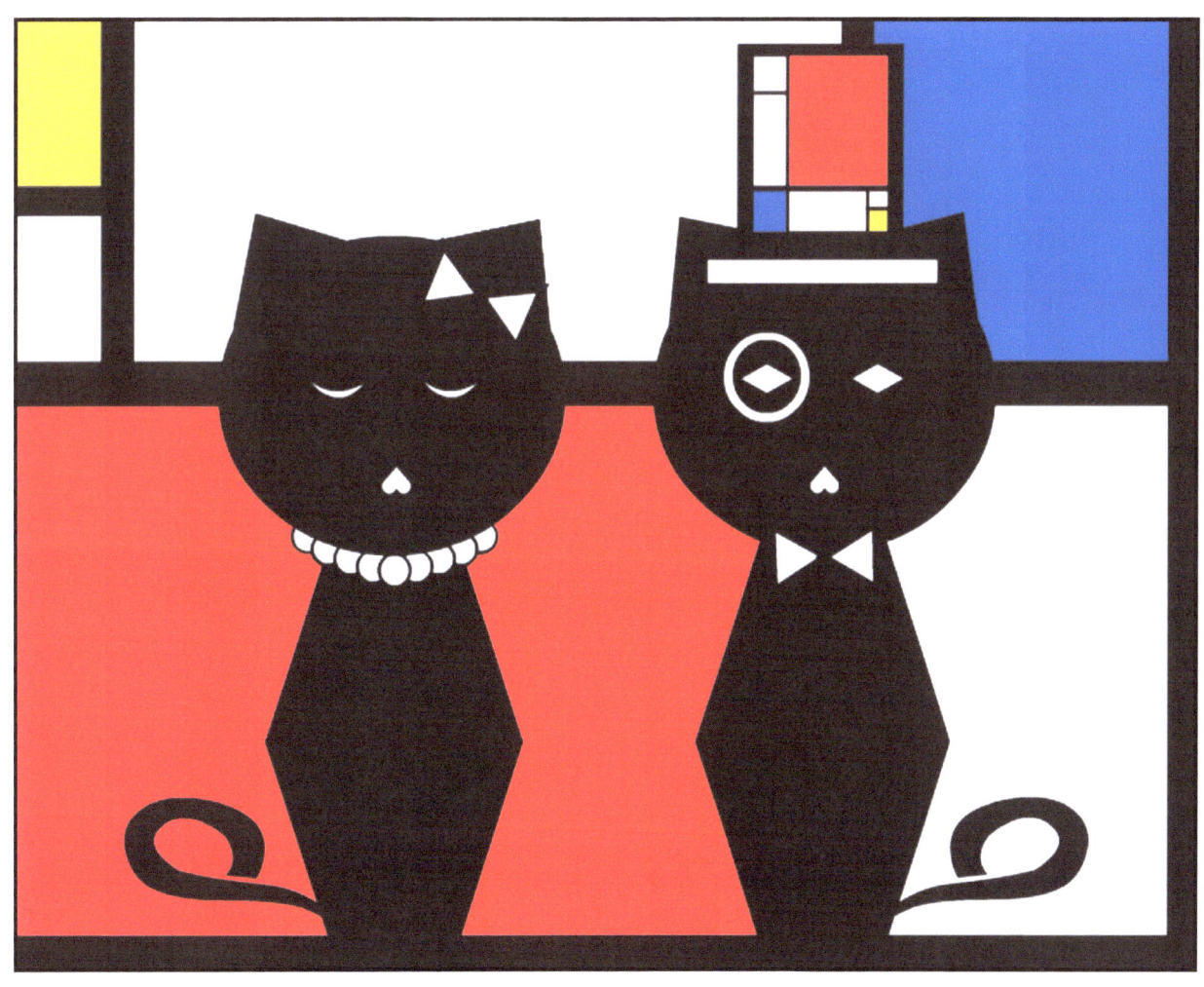

Pest Modernism

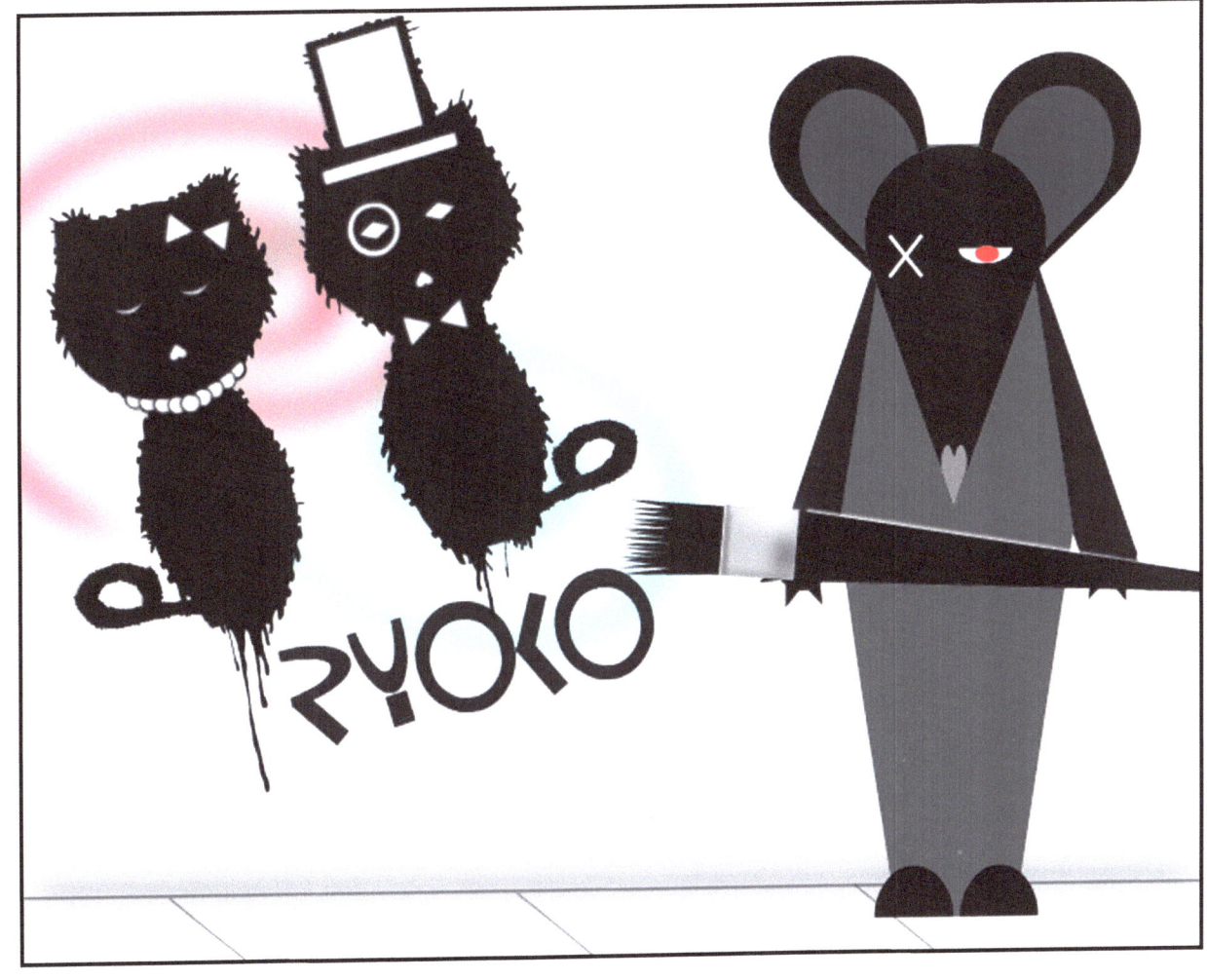

Blue

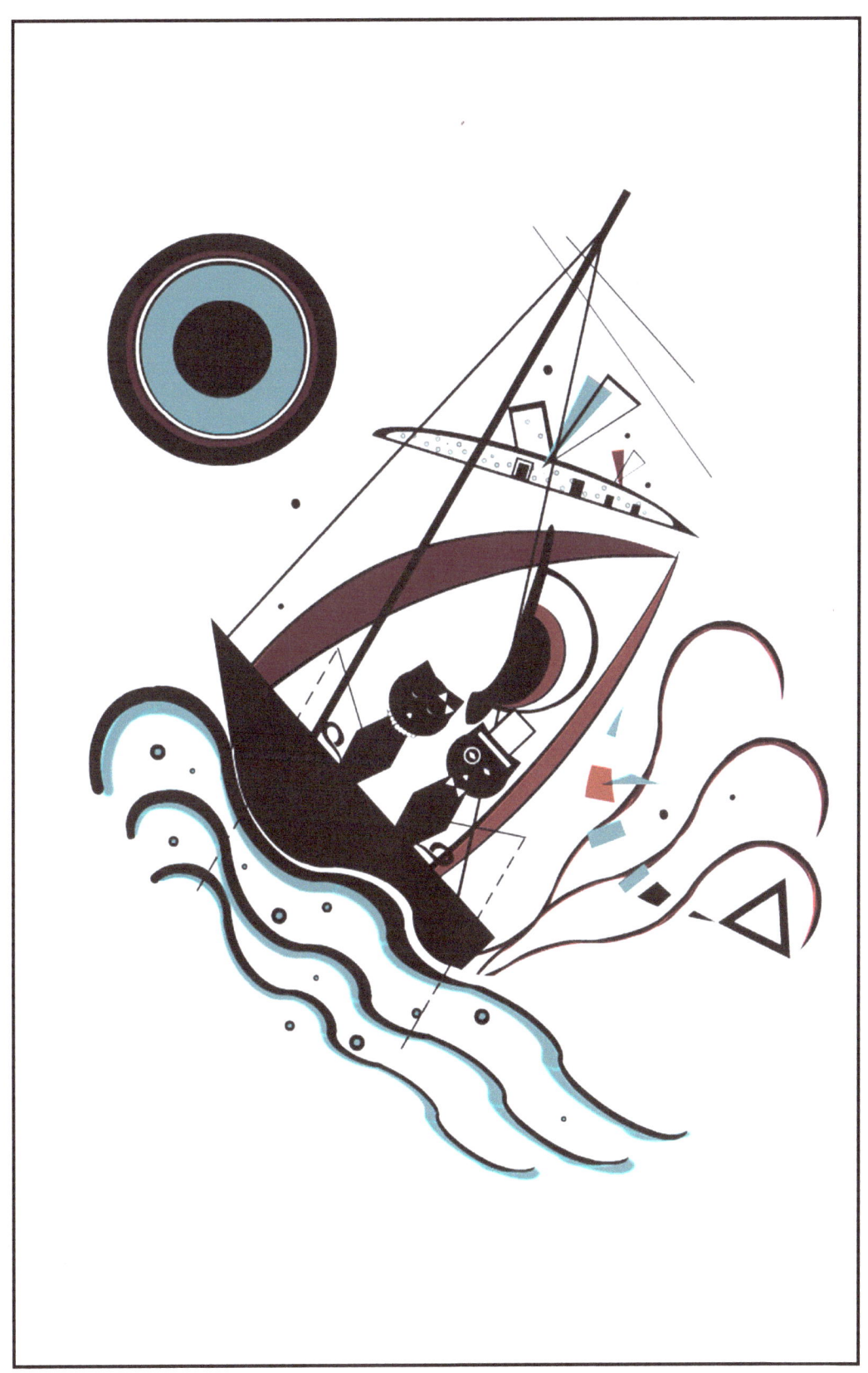

Symphony in Black

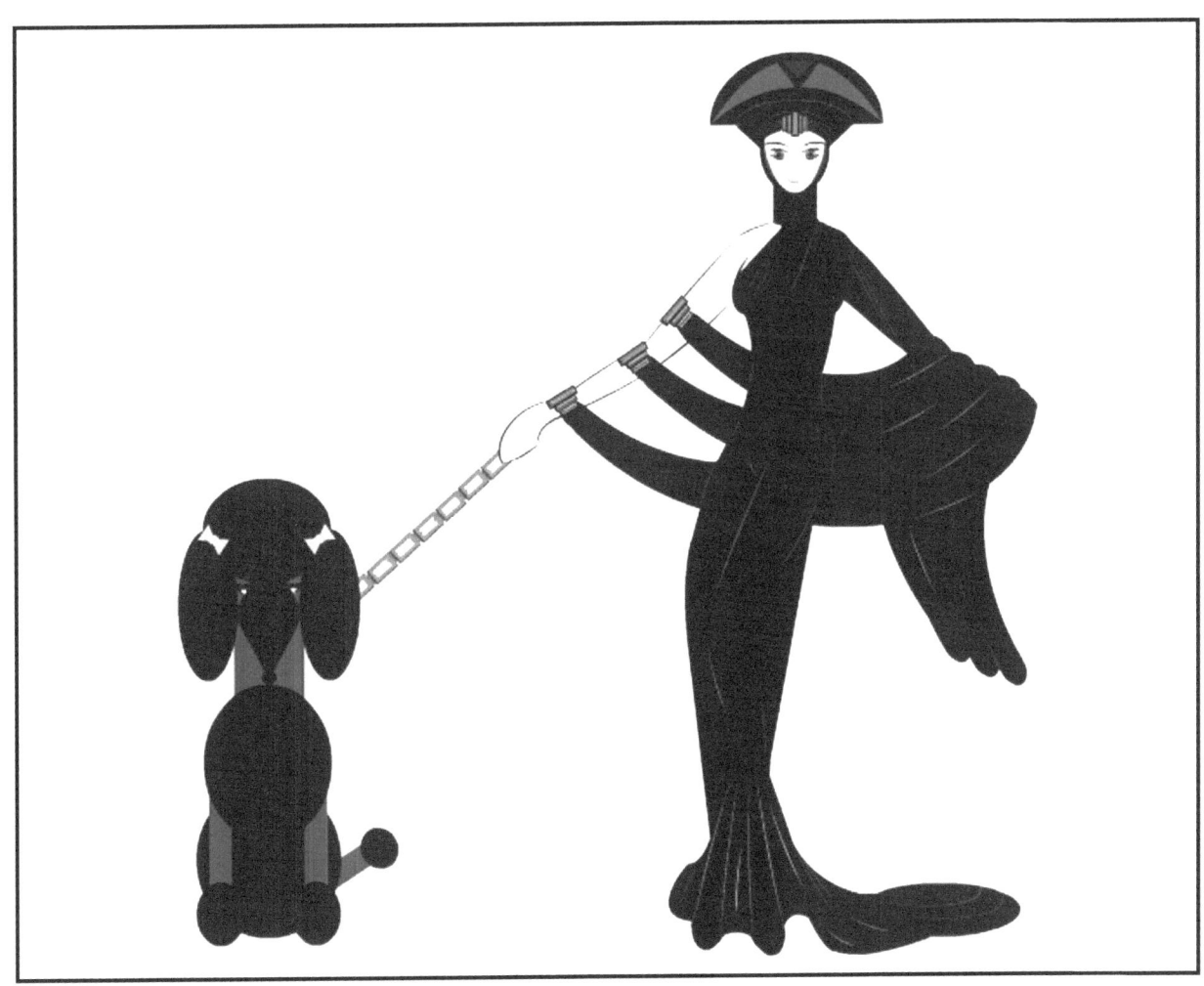

Cubist Kitten

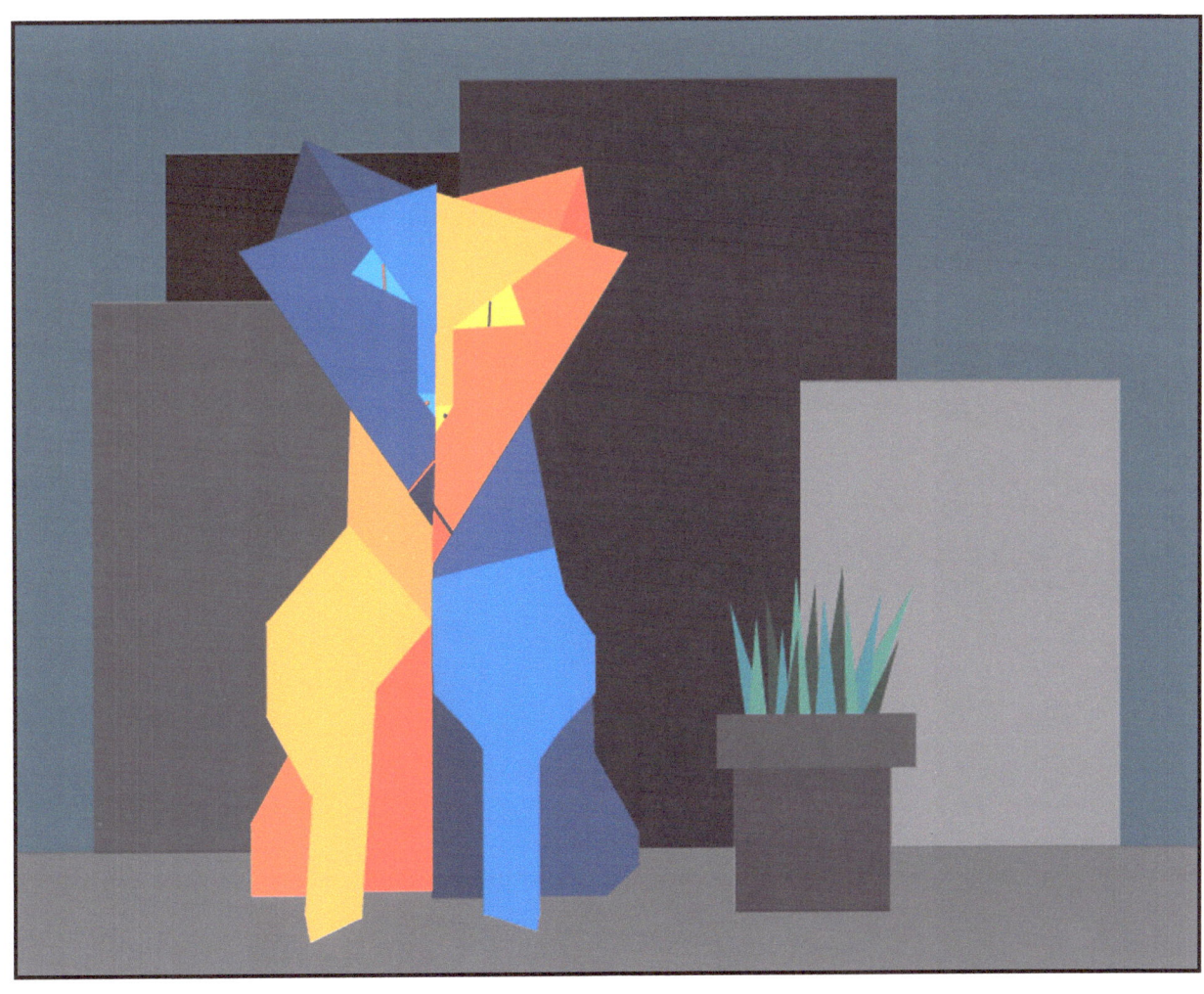

Proun

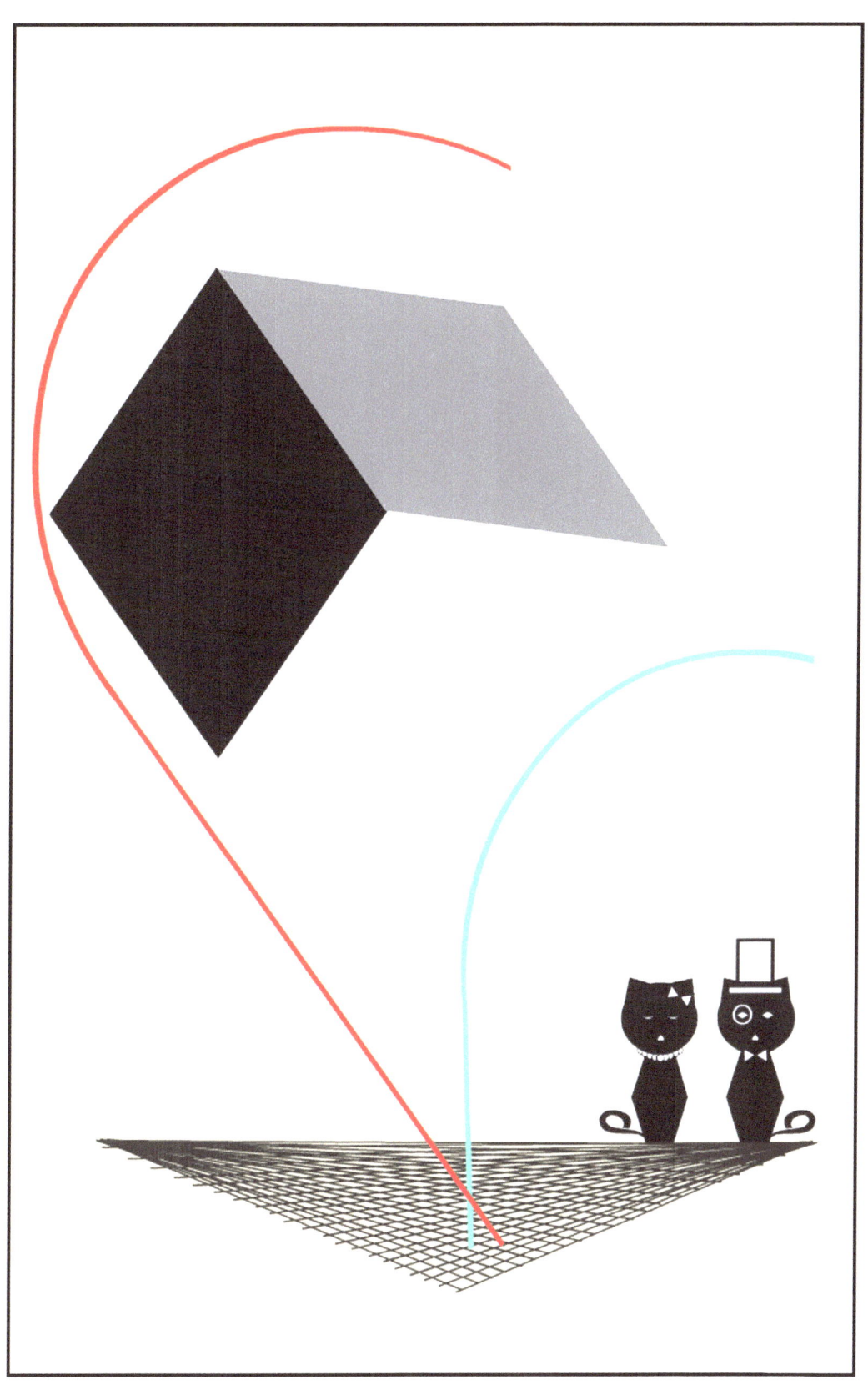

Morning Kitten & Evening Kitten

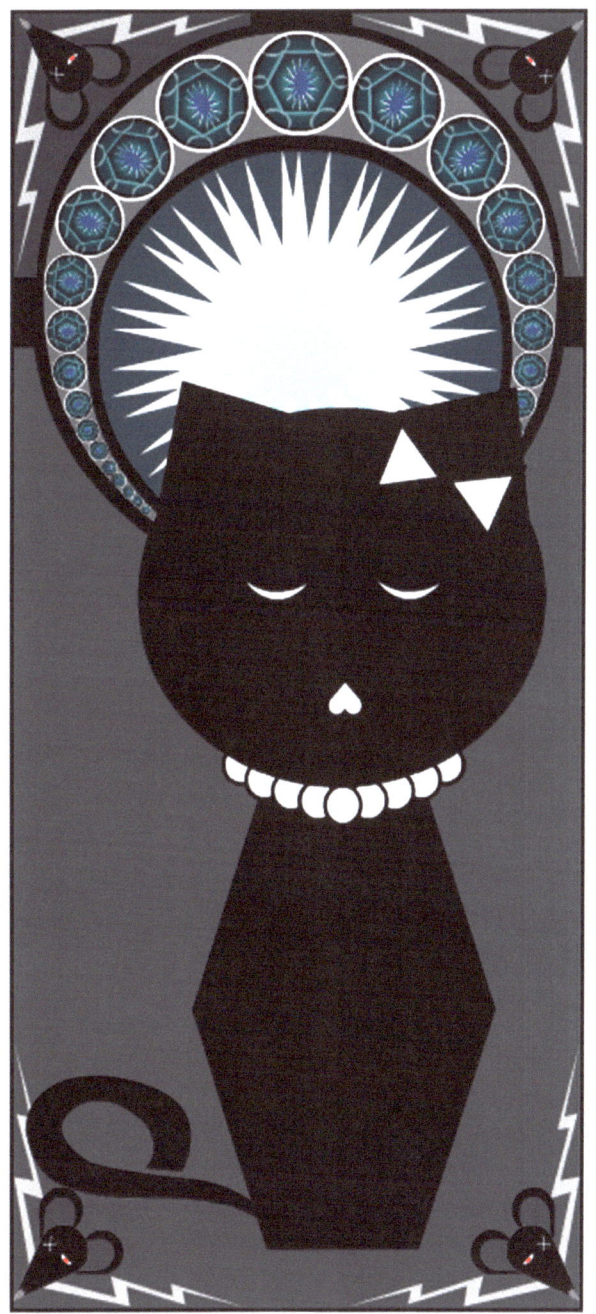

After Dark

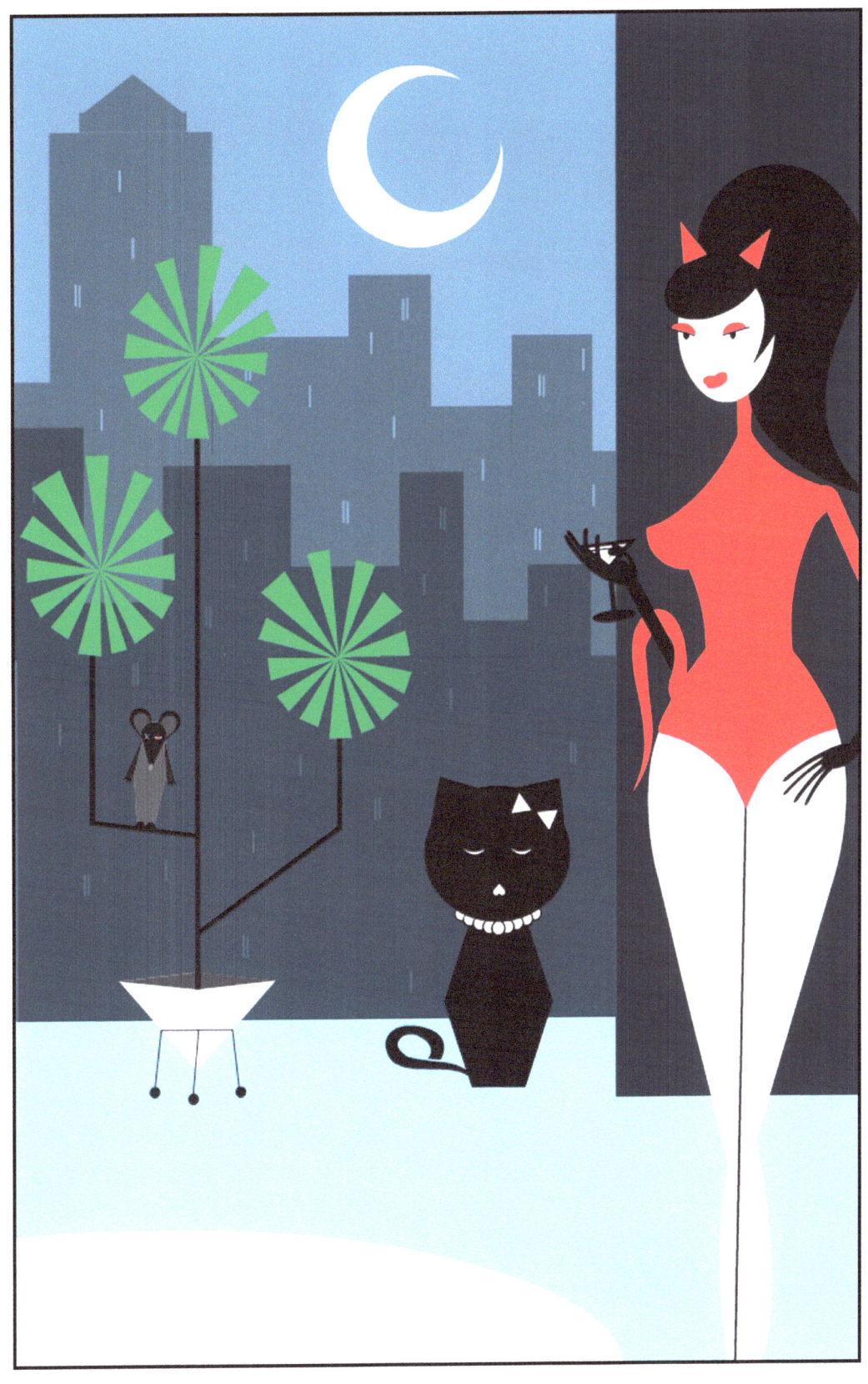

Flower That Blooms at Midnight

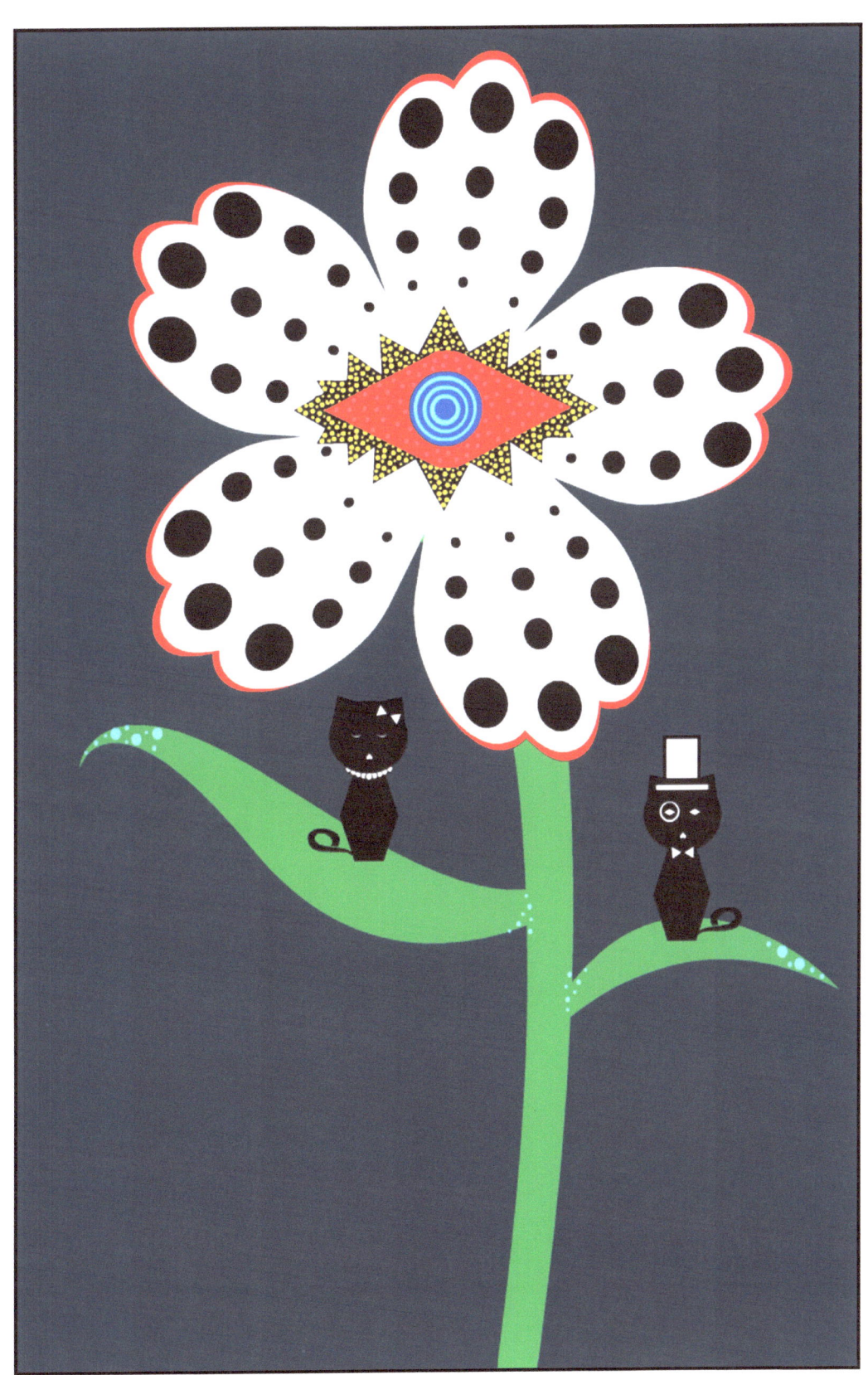

Arithmetic Composition

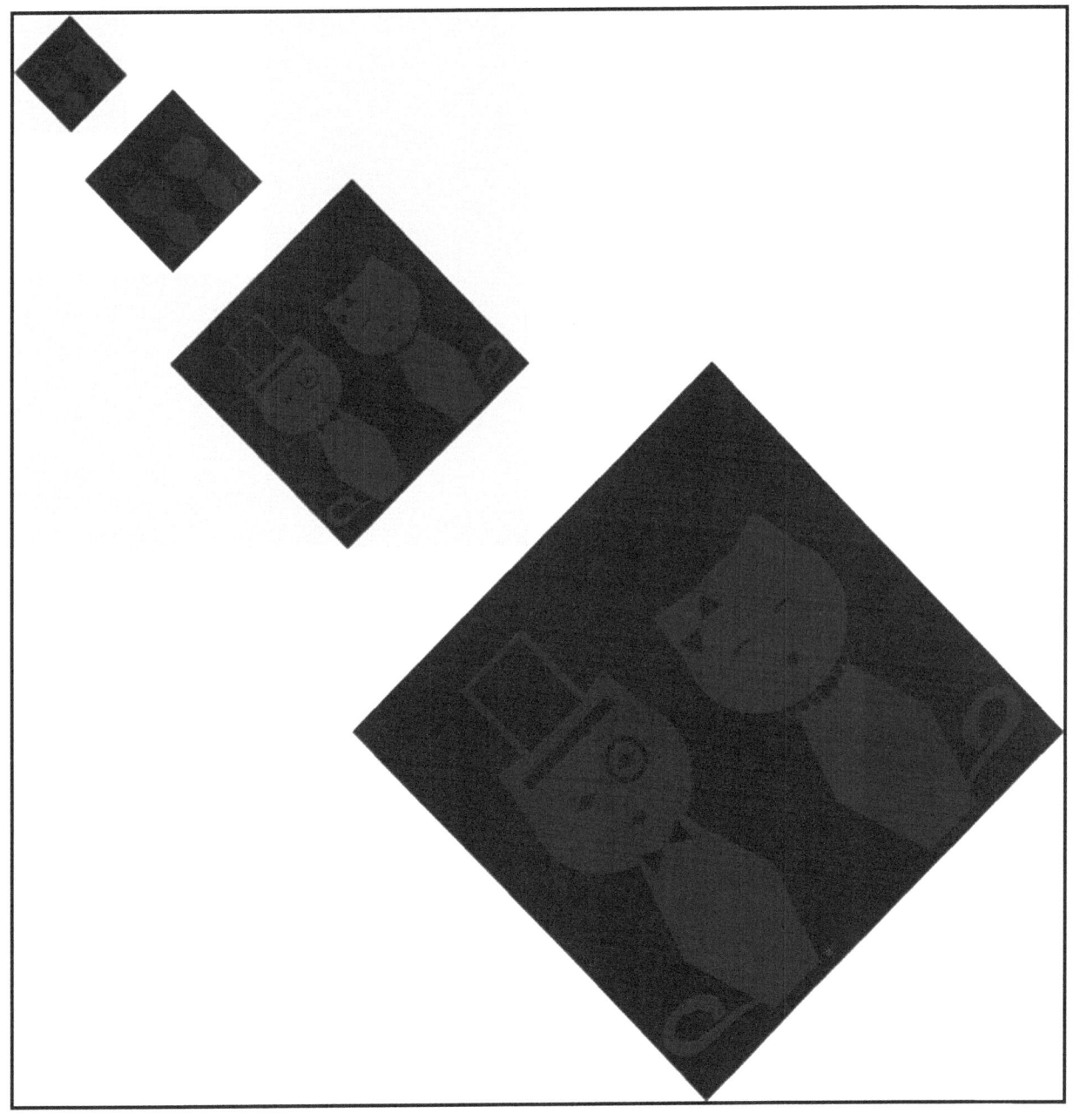

The Last Mad Tea Party

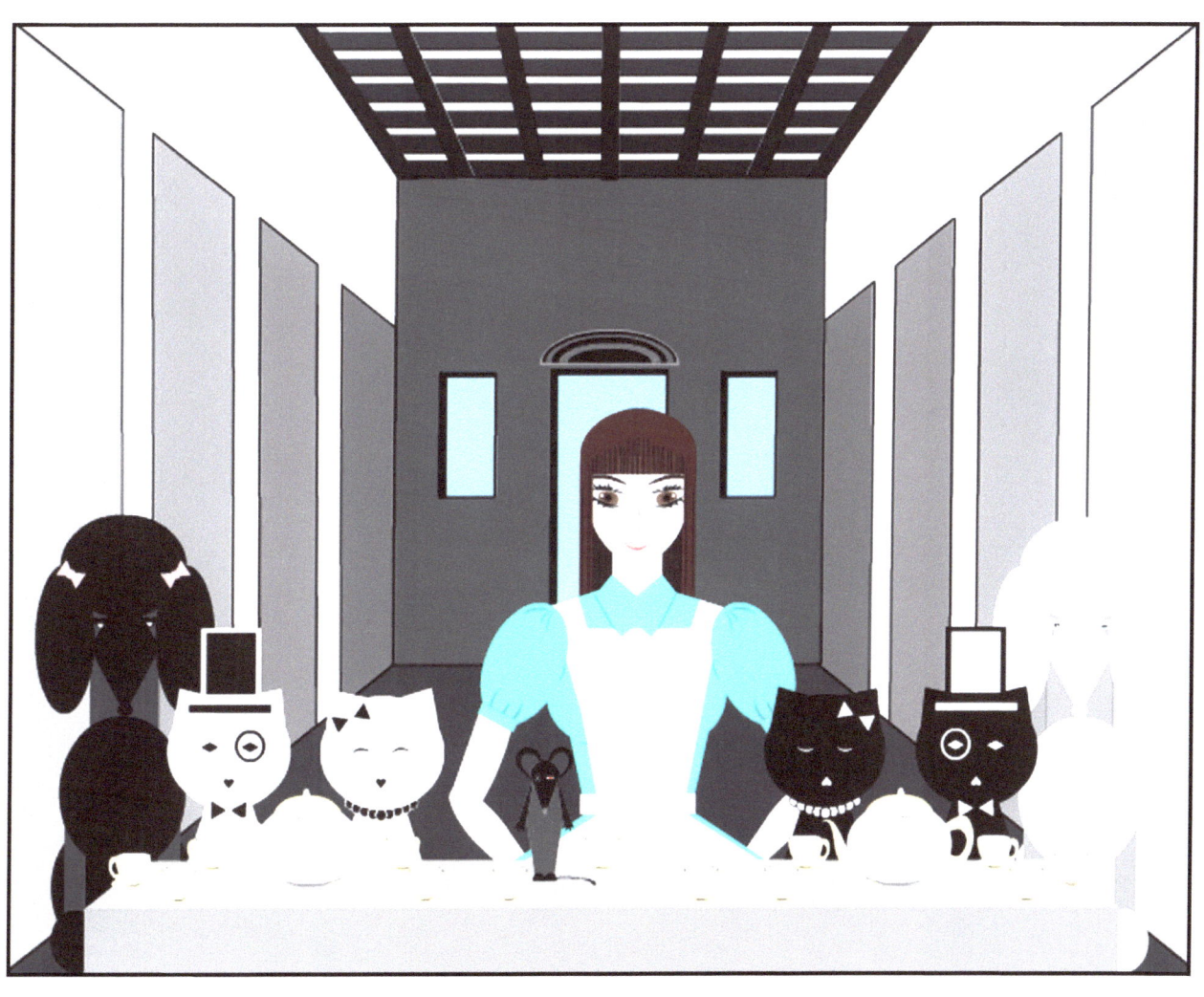

Noodle Notes

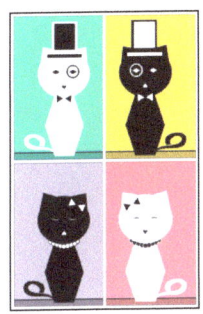

Four Noodle Kittenses December 17, 2010

Artistic Inspiration: Andy Warhol/ *Marilyn* series (1964) often referred to as the *Shot Marilyns*

Title Inspiration: Andy Warhol/ *Eight Elvises* (1963)

Interesting Facts: The *Marilyn* series is often referred to as the *Shot Marilyns*, because 4 of the 5 pieces in the series were shot through the head with a single bullet by Dorothy Podber. *Eight Elvises* is Warhol's highest selling piece to date. Both are classified as Pop Art.

American Gothic December 23, 2010

Artistic Inspiration: Grant Wood/ *American Gothic* (1930)

Interesting Facts: *American Gothic* is painted in the Regionalist style and is one of the most parodied artworks of all time. The two figures are often misinterpreted as being husband and wife; however, Wood intended them to be perceived as a father and his daughter.

Composition in Red, Blue, and Yellow December 29, 2010

Artistic Inspiration: Piet Mondrian/ *Composition II in Red, Blue and Yellow* (1930)

Interesting Facts: Mondrian is known as the father of Geometric Abstraction and deemed a pivotal figure in the Modern Art movement. He displayed OCD tendencies as his artist's studio looked more like a sterile laboratory. *Composition II in Red, Blue and Yellow* is categorized as Neo-Plasticism, the predecessor to Geometric Abstraction.

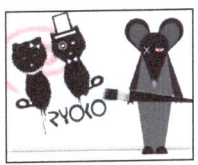

Pest Modernism January 6, 2011

Artistic Inspiration: Banksy/ *Pest Modernism* (2004)

Interesting Facts: The rat is a recurring theme in Banksy's work. He often uses stencils to create his art. Banksy is more than a graffiti artist; he made a film that was released in 2010 titled *Exit Through the Gift Shop* which was nominated for the 2010 Academy Award for Best Documentary. To date, his identity is still a mystery.

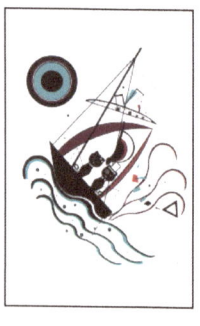
Blue
January 13, 2011

Artistic Inspiration: Wassily Kandinsky/ *Blue* (1922)

Interesting Facts: Kandinsky gave up a successful career as a law professor to follow his passion for art. Some credit him for creating the first purely abstract works of art. *Blue* is considered a work of Expressionism.

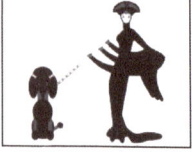
Symphony in Black
January 20, 2011

Artistic Inspiration: Erté/ *Symphony in Black* (1983)

Interesting Facts: Erté is not this artist's given name but rather the French pronunciation of his initials R.T. He is most recognized for his Art Deco costume and fashion designs; however, he also created several series of paintings depicting concepts such as the alphabet, the numbers, the elements, and the zodiac.

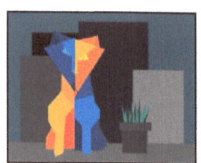
Cubist Kitten
January 27, 2011

Artistic Inspiration: Cubist Movement (Early 20th Century)

Interesting Facts: This image is a reproduction of an acrylic painting I created many years ago in the cubist style. Cubism is considered by some to be the most influential art movement of the 20th century.

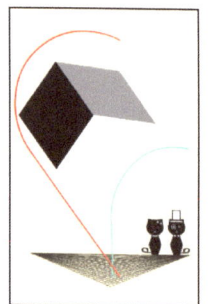
Proun
February 10, 2011

Artistic Inspiration: El Lissitzky/ *Proun Inv. 91* (1925)

Interesting Facts: El Lissitzky started his career as an illustrator of Yiddish children's books and became an important figure in the Russian avant-garde. *Proun* is a series of paintings, lithographs, and installation pieces that explores Suprematism, an early 20th century art movement based on fundamental geometric forms.

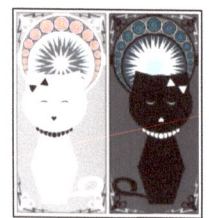
Morning Kitten & Evening Kitten
February 17, 2011

Artistic Inspiration: Alphonse Mucha/ *The Arts Series* (1898)

Title Inspiration: Alphonse Mucha/ *The Moon and the Stars Series* (1902) specifically the pieces *Morning Star* and *Evening Star*

Interesting Facts: Mucha is a key figure of the Art Nouveau movement. The work that is credited for launching his career was *Gismonda*, a poster promoting the Greek melodrama starring Sarah Bernhardt which also gained him a lengthy commission with the actress. Art Nouveau is sometimes referred to as "the noodle style" due to its use of intertwining organic forms.

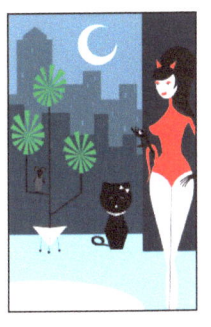
After Dark
February 24, 2011

Artistic Inspiration: Shag/ *Tabby* (2006)
Title Inspiration: Shag/ *After Dark* series (2006)
Interesting Facts: The real name of the artist Shag is Josh Agle. Shag is the combination of the last 2 letters of his first name and the first 2 letters of his last name. He is often categorized as a lowbrow artist of the Pop Surrealist movement.

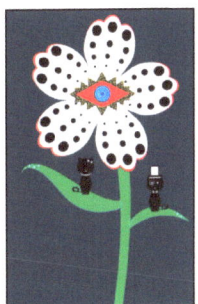
Flower That Blooms at Midnight
March 3, 2011

Artistic Inspiration: Yoyoi Kusama/ *Flowers That Bloom at Midnight* sculpture series (2009)
Interesting Facts: At the beginning of her career, Yoyoi Kusama was considered to be an influential figure in the Pop Art movement but is now considered a Conceptual artist. She has lived voluntarily in a psychiatric institution since 1977. She is often referred to as the Princess of Polka Dots due to the prominence of polka dots in her art.

Arithmetic Composition
March 10, 2011

Artistic Inspiration: Theo van Doesburg/ *Arithmetic Composition* (1930)
Interesting Facts: *Arithmetic Composition* is a mathematical creation in which the sides of each square and the distance between them are half the size of the preceding square. Theo van Doesburg was the founder and leader of De Stijl also known as Neo-Plasticism, a simplification of visual compositions to the vertical and horizontal directions using only primary colors along with black and white. However, *Arithmetic Composition* is classified as Concrete Art, an art movement that evolved out of De Stijl.

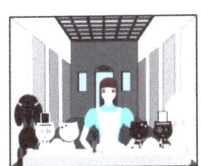
The Last Mad Tea Party
March 17, 2011

Artistic Inspiration: Leonardo Da Vinci/ *The Last Supper* (Late 15th Century) and John Tenniel/ *The Mad Tea Party* from Lewis Carroll's *Alice's Adventures in Wonderland* (1865)
Interesting Facts: Leonardo Da Vinci and Lewis Carroll were both mathematicians and artists. *The Last Supper*, a wall mural from the Renaissance, has many perspective lines that intersect at the right eye of Jesus. *Alice's Adventures in Wonderland* has been published numerous times with a wide variety of illustrators. John Tenniel illustrated the first edition; however, Lewis Carroll illustrated the original manuscript.

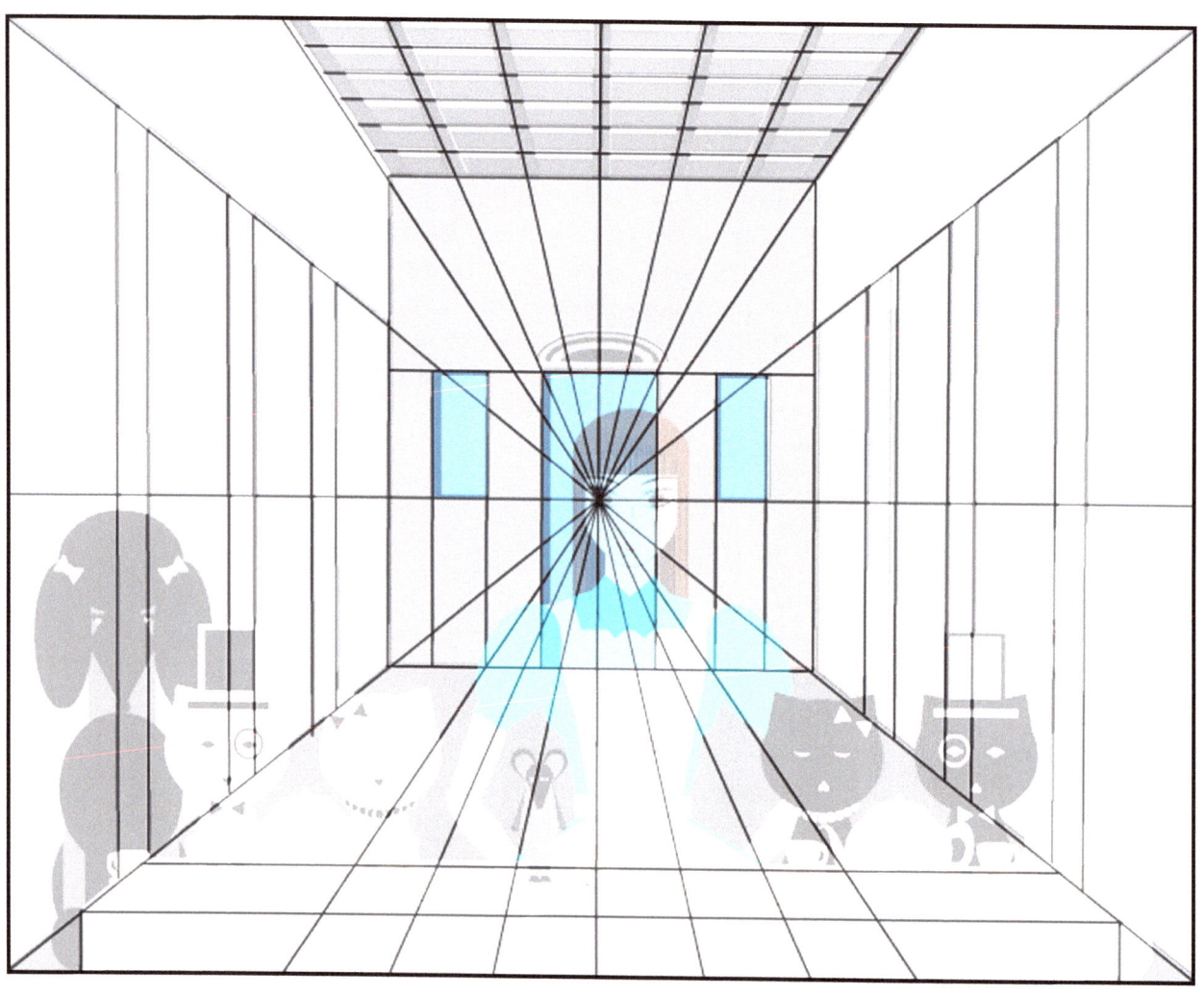

Acknowledgements

First and for most, I must thank my family for being so supportive throughout my artistic endeavors as I tend to get obsessive and manic when I am in the midst of the creative process.

I would especially like to thank my mom who often gave me leads on interesting artists and art movements due to her vast knowledge of art history. She even created an artist's book of this series for my private library.

Finally, I would like to thank Stripgenerator. If it was not for the ingenious innovation of its creators, I doubt the Noodle Kittens would exist outside of my imagination. A special thanks to the Stripgenerator community for indulging me with thoughtful comments and accolades.

The fonts used throughout this book are Dream Orphans and Franklin Gothic Book.

All images were created on Stripgenerator.com.

Cover and title page image: *The Artist's Model* (June 30, 2012)

Image page 34: Overlay of *The Last Mad Tea Party* with the sketch (March 13, 2011) showing the perspective lines I used to create the finished work based on the perspective lines used in DaVinci's *The Last Supper*.

Image page 36: *Noodle Kittens Tutorial* (January 4, 2011)

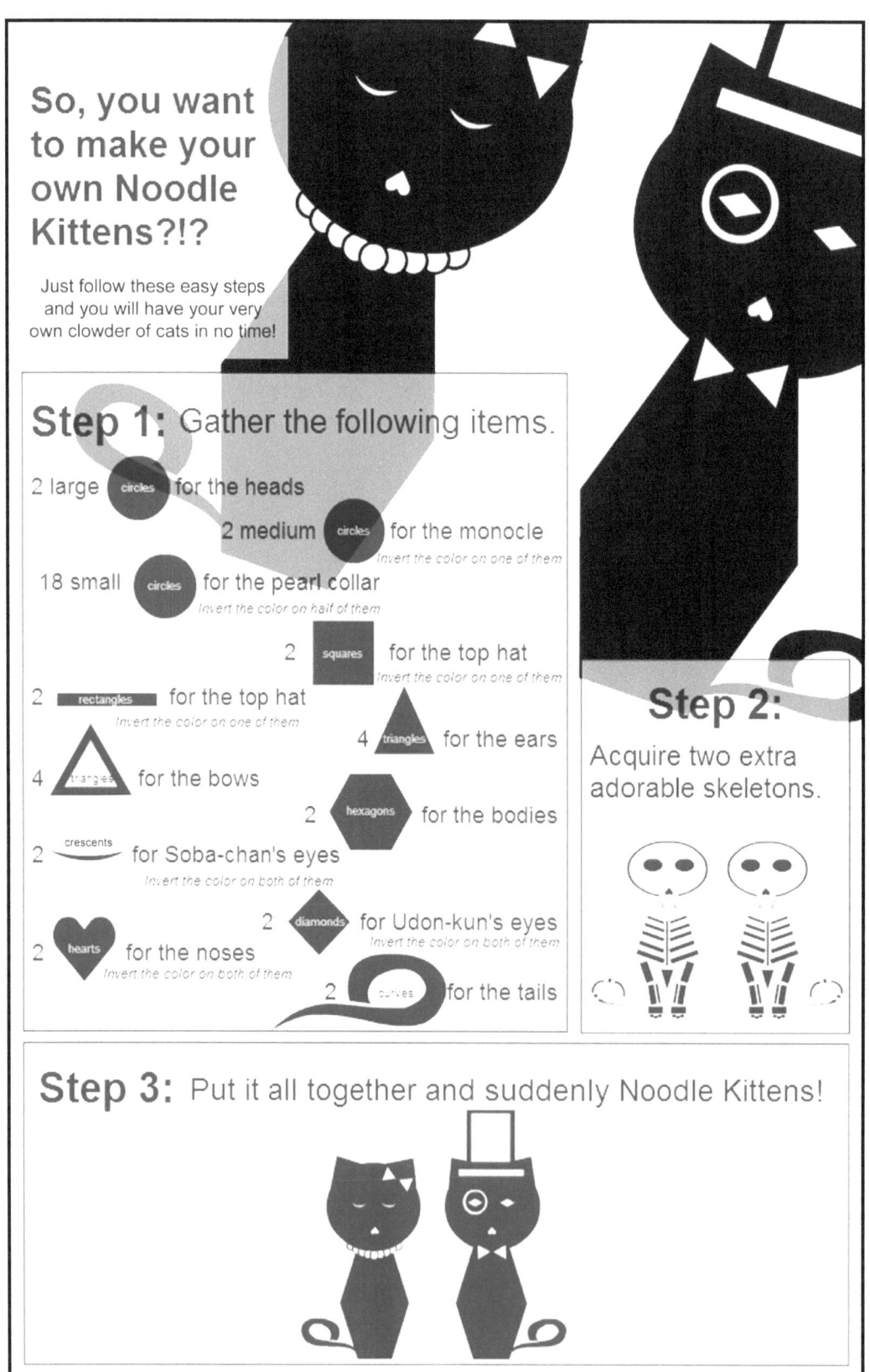

About the Author

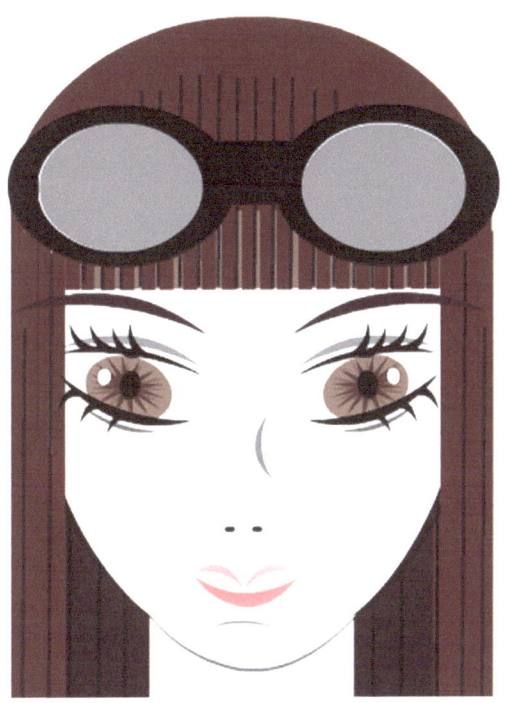

Ryoko San is an artist and a mathematician.

Beyond that, she prefers to remain mysterious.

www.ingramcontent.com/pod-product-compliance
Lightning Source LLC
Chambersburg PA
CBHW051107180526
45172CB00002B/811